W9-AWN-326

AMERICAN
PIECED QUILTS

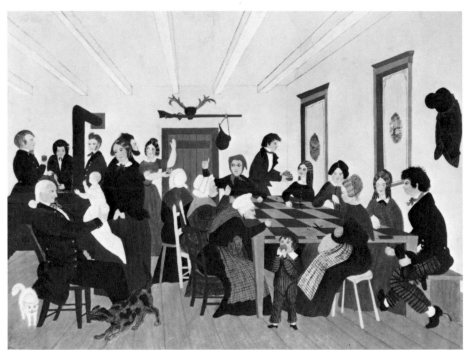

*«The Quilting Party», artiste inconnu, ca. 1880. Huile sur panneau.
Collection : The Abby Aldrich Rockefeller Folk Art Collection, Williamsburg, Virginia.*

AMERICAN PIECED QUILTS

JONATHAN HOLSTEIN

A STUDIO BOOK
THE VIKING PRESS · NEW YORK

First published in Switzerland by Editions des Massons sa
17 chemin des Fleurettes Lausanne
Published in 1973 by The Viking Press, Inc.
625 Madison Avenue, New York, N.Y. 10022
Published simultaneously in Canada by The Macmillan Company of Canada Ltd.
SBN 670-12004-9
Library of Congress Catalog Card Number: 72-11905
Printed in Switzerland by Imprimeries Réunies sa, Lausanne

American Pieced Quilts

This is an exhibition of American pieced quilts, chosen in a particular way: all elements of craft expertise, all consideration of age, condition, historical or regional significance have been disregarded, and we have concentrated only on how each quilt works as a "painting". That is, does it form a cohesive, strong and important visual statement? Thus our interest is in the images the quilts form, and not in their stitches; many are in poor condition, have some machine work in them, or, indeed, exhibit a level of workmanship which would be unacceptable to those interested mainly in fine craftsmanship.

Quilting is an ancient craft, its basic technique unchanged for millenia: two layers of material, usually with a filler in between, are stitched through to join them together. The purpose of quilting is twofold, decoration and protection, the latter against blows, as in quilted body armor, and through insulation. It is a very efficient method of protecting against both heat and cold (potholders are often quilted, sleeping bags always are).

Among the many ancient and modern products of the craft (quilted clothing, padding under armor, window and bed hangings, simple mattresses and the like) is the common "quilt", or bed cover. A quilt usually has three parts, the "top", or part which carries the main design, a back, and the filler in between which can be a variety of organic or inorganic substances but is usually either cotton or wool batting, the latter where warmer quilts are desired (modern quilt makers are increasingly using synthetics). Bed covers made with a top and back stitched together but with no filler are also considered quilts. In America, quilts are made this way: the craftsman first designs and makes the top; when this is completed, a backing of the same size as the top is stretched on a quilting frame (similar in design to an ordinary picture frame) and tacked down. The filler is spread evenly over the back, the top laid over and stretched tight, pattern lines drawn on the top, and the quilter stitches the three parts together following the lines.

There are three basic types of quilts, differentiated largely by the treatment of their tops. Plain quilts use a single piece of material for the top; sometimes, in older quilts, this was embroidered. The commonest surviving American plain type

is the "white-on-white" quilt, which has a one-piece white top, the decorative effect coming only from the quilting stitches and the raised patterns this produces. Designs are drawn on the top and these lines followed in the quilting. Geometric and naturalistic forms predominate, and often there are elaborate central medallions or figures. In its most elaborate form the areas between the stitches are stuffed out to make highly raised figures, as in trapunto work. Tops of the other two types, applique and pieced quilts, are made in two techniques often collectively called "patchwork" but actually quite different. In applique work, forms cut from one piece of cloth are applied, stitched down, to a piece of whole cloth which forms a background for the design. In pieced work pieces of material, usually precut to particular shapes, are stitched together edge-to-edge to conform to predetermined patterns. Designs for most American pieced (and many applique) quilts are built up from blocks which repeat a single pattern and form the overall design of the quilt when they are put together to complete the top. Pieced quilt designs are usually geometric, the parts of each block working in close relation to those surrounding it to make the larger forms and arrangements of color and line. These formal relationships are maintained by the meticulous care with which the parts are measured, cut and sewn, so that they will link perfectly when joined. Very often the ways in which the individual blocks will combine to form the overall design are extremely complicated, and it is sometimes impossible to envision, without elaborate computations, the finished quilt design from a single block. The tops of so-called "crazy" quilts are made by fitting together pieces of cloth of random size and shapes. In both applique and pieced quilts the quilting is often done in patterns which add secondary, textual motifs, or, following the designs of the top, enhances those.

The settlers who left seventeenth century Europe for the New World had a traditional knowledge of quilting; and it is reasonably certain that quilts were among the household possessions which crossed the Atlantic with them. What these looked like can only be surmised, as none survived in America (quilts dating before the nineteenth century are rare on either side of the Atlantic). However, to judge from European examples, any fine quilts they brought would likely have been in general subdued and of the plain type, the decorative effects more from fine

quilting and perhaps some embroidery than color and variety of materials. Possibly there were also some precious, livelier quilts of silk, and almost certainly rougher quilts of coarse materials used both for covers and mattresses.

Because of the often inhospitable climate of the Eastern coast and the consequent need for warm bed clothing, it has been surmised that the colonists began to make quilts from the beginnings of settlement. The further conjecture has been that, given the absence at first of native wool and flax industries and the lack of a ready supply of new cloth, the first American quilts were pieced, made from the salvageable pieces of worn out clothing and other cloth articles fitted together in random or "crazy" fashion. But no direct proof supports either contention. And while it is probable that quilts were made, what type they were cannot be stated.

There is a likelier beginning for those patchwork-type quilts which were to flourish during the later eighteenth and the nineteenth centuries, and whose development and elaboration was an American phenomenon. Trade with the Indies, vastly expanded in the seventeenth century by the English, Dutch and French, brought to those countries the brilliant painted, printed and embroidered cottons, and the quilts made from them, for which India was justly famous. Gradually, fashionable tastes developed for these fabrics, along with efforts in France and England to suppress their importation as ruinous to home textile industries. But large amounts of the materials got in, one way or another, and were the rage of the eighteenth century. In England, with which we are most concerned because of the English background of many early settlers and the likelihood that a great part of America's original quilt tradition came with them, one patchwork quilt of the first decade of the eighteenth century survives. It uses Indian cottons appliqued to a white background, and it seems probable that such quilts were made earlier, in the seventeenth century. The strong decorative effects inherent in even small pieces of these gay materials, with their finely-lined yet bold and distinctive patterns, and the desire to make them go as far as possible, given their relative expense, most likely prompted their use in pieced and applique techniques and thus the growth of these types of quilts. Also, they offered a kind of instant embroidery, instant at least by the standards of the time: whole figures of animals, plants, people could be cut from the materials and stitched down, the

effect at a little distance remarkably like fine embroidery. Both as old and new scraps, pieces of these materials found their way into patchwork quilts. Unfortunately, the scanty evidence makes it impossible to say exactly when or where the first patchwork quilts using these fabrics might have been made. (And it is of course possible that it was a New World craftsman who first used precious scraps of chintz for such a purpose.)

Home wool and flax manufacture was well-established in America long before the seventeenth century was over. Trade with Europe flourished as the colonies grew and prospered, bringing a wide variety of textiles, including Indian goods transshipped through Europe. Inspired by the Indian fabrics and an eager market at home and abroad for printed, color-fast materials, the manufacture of such textiles burgeoned in later eighteenth century Europe, and much was exported to the New World. Also, it was not long into the eighteenth century before the colonists were themselves printing on fabrics, and home weaving provided a steady supply of sturdy fabrics. So the raw materials for pieced quilts were generally available at an early date, the more expensive imported fabrics, because of their bold patterns and color-fastness, being particularly suitable for patchwork. Some of the rare American quilts of the later eighteenth century show the use of both applique and pieced techniques, sometimes combined in a single quilt.

As might be expected, needlework was a highly-prized, indeed, an essential feminine skill. In America as in Europe, an integral part of every girl's education was the competent production of sewn articles. For the leisured, it was a necessary social grace; for those who depended on the work of their hands to keep their families in clothes and their homes in bed clothing and other necessary cloth articles, it was an absolute necessity. In the eighteenth and early nineteenth centuries young girls' education in stitchery was started when they were as young as three, and it continued, through much practical application, until they left the home. Nor were they immune at school, as many advertisements for girls' schools, emphasizing needlework in their curricula, testify. In many parts of the country girls were expected to have thirteen quilt tops, twelve everyday and one special bridal top, on which the greatest care and the most expensive materials they could afford were lavished, ready for their engagements. When they were betrothed, a quilting "bee"

was announced. Female relatives and friends from the region gathered, bringing food and appetites whetted for good company. During the day the girl's bridal top was set up in the quilting frame with back and filler and quilted by the womenfolk, the men arriving later for feasting, dancing, courting and celebration of the betrothal. The quilting bee was not confined, however, to such special occasions. It became, both in rural and urban America, the great woman's social institution of the nineteenth century, a chance to meet, exchange gossip, renew friendships, and, if the men were to be invited, indulge in all of those festivities which were part of that era of American social life.

Quilt-making reached its height in America during the nineteenth century. As the era progressed, domestic manufacture of materials flourished. Ladies' magazines carried the most popular quilt patterns of the day, quilts were judged along with other prized products of family industry at the ubiquitous regional fairs, reputations rose and fell with the beauty of quilts and the skill with which they were worked. During this time a sharper distinction between applique and pieced quilts came about, the former in general becoming the "best" quilts, the latter, the utility or everyday quilts. As materials became increasingly abundant, people were willing to use them more lavishly in the making of applique quilts. Elaborate designs requiring the cutting of whole cloth were invented, often with many curves, more difficult to sew than the usually straight lines of the pieced patterns. And the most sumptuous quilting was often employed, endless hours of meticulous stitchery. Sometimes these quilts were years in the making.

But the pieced quilt did not decline certainly not aesthetically, nor in the amount of inventive energy it absorbed. It was a quintessentially American product, combining economy and utility with strong, spare and original design. While the craft may have been originally an import, the great development of quilt design, especially that type which uses repetitive figures building to an overall effect, was distinctly American. Waste was intolerable to the thrifty Yankee spirit; the scraps left over from clothesmaking and the good parts of worn garments went into the ever-present scrapbag, from which was drawn the raw materials for pieced quilts. It was a source of supply kept by most families, and while not every family could afford or needed the fanciest quilts, each needed some form of bed cover; the

pieced quilt answered this need. Also, while the applique quilt might have been considered better by some, the skillful and inventive woman, using energy, taste and ingenuity, could create from otherwise useless scraps a pieced quilt masterpiece, unerringly sewn, gloriously quilted, equal in the eyes of all but the haughtiest to the fine applique quilts. Both the sense and the actuality of thrift were thus triumphantly served, prized feminine virtues visibly demonstrated.

Quilt-making might seem tedious to us—the hundreds of hours, the hundreds or thousands of pieces to put together with yard after yard of thread painstakingly applied—so much effort to make a bed cover. But for these women it was a most welcome task. Much moving contemporary testimony exists to the great pleasure they found in planning and executing their quilts; it furnished a needed relief from the real labor of family maintenance. Beyond that, quilts served for a number of generations as a unique creative outlet for American women. (It might be mentioned that men also designed and made quilts, but their role was more in the planning than in the sewing.) Within the medium she could express both her feelings for color, form and line and her responses to the American experience. The natural world, politics, religion, history—all were represented in quilt designs: Burgoyne Surrounded, Bear's Paw, Delectable Mountains, Underground Railway, Tree Everlasting, Whig's Defeat, Lincoln's Platform, Rocky Road to California, Kansas Troubles, Ducks-Foot-in-the-Mud, Yankee Pride, Corn and Beans, Jacob's Ladder, Mrs. Cleveland's Choice, Old Maid's Ramble, Pride of the Forest, Seek-No-Further ... the names are delicious. As migrations within the country took place, the changing environments and social conditions the settlers encountered prompted the development of new patterns and variations in the ones they had carried with them. One can see this in the changing names and forms of essentially similar quilt patterns: what was the "Ship's Wheel" on the East coast became the "Prairie Star" in the midwest. Often these patterns were visual abstractions of the images and ideas. "Wild Goose Chase", triangles following in rows apex to base, was the wedges of geese which passed with the seasons. "The Drunkard's Path" is a twisting one, difficult to negotiate.

Each region put its own stamp on its quilts, a combination of particular environmental and economic conditions and the traditions of the settlers who went there.

Thus Pennsylvania quilts can reflect either the somber tastes of the Amish, or the gay, often riotous color inventions of the less orthodox Pennsylvania Dutch. Southern quilts are elegant, understated, those of the Ohio Valley are rich in stylized natural forms and often superbly quilted, New England quilts are restrained.

Both the times and changing fashions also marked quilts. When times were expansive, quilts were exuberant; in periods of doubt or trouble, quilts became more subdued. Obviously, fashion is all of a part with this, since pieced quilts were made largely from clothesmaking remnants, and, when fashion and the times decreed gay clothing, quilts were livelier, when it became proper to dress in somber hues, quilts became darker. Cottons and wools, velvets and silks, materials in and out of fashion, each a different texture, working in a particular way in the design and on the eye. Always quilts reflect the prevailing tastes and moods of their times.

While American applique quilts are distinctive and often beautiful, their stylized designs, drawn largely from nature, a unique contribution to decorative art, we have concentrated on pieced quilts in this exhibition for a simple reason: they are to our eyes more interesting aesthetically. Pieced and applique quilts share basic similarities in design techniques, yet their overall effect is usually quite different. This may be due precisely to the "best" status of applique quilts, making them more self-conscious in conception, more consciously "elegant". They remain, for the most part, "pretty", while the best of the pieced quilts, by which I mean the most moving visually, have a toughness in idea and execution, an often astonishing bravado in the use of design elements difficult at first to equate with the aesthetic ambiance of their times—unless it is noted that the quilts came more from the sensibilities which produced the utilitarian objects of the period than from those which made decoration. The finely realized geometry of the pieced quilt, coupled with this sophisticated sense for the possibilities of color and form, produced some works which mirror in startling way contemporary painting trends. We can see in many such phenomena as "op" effects, serial images, use of "color fields", a deep understanding of negative space, mannerisms of formal abstraction and the like. Too much, can, of course, be made of these resemblances, to the confusion of the intrinsic merits of both the paintings and the quilts. They were not made as paintings, nor did the people who made them think of themselves as "artists". But it is legitimate

to emphasize the ways in which conscious control was exerted over the materials for aesthetic ends. First, the planning of the quilts involved a long series of aesthetic decisions. Which, among the literally hundreds of existing patterns, should be chosen? Should a new one be invented, or a variation made on a standard one? How big should each block be? What colors should be used, and what textures? Should the blocks be set together, or separated by strips, should there be a border, or borders? It is obvious that the possibilities were infinite, and that within the framework of the technique each woman had full freedom to make aesthetic decisions. The design of these quilts was in no sense haphazard or naive, even the "crazy" quilts showing the most careful planning for aesthetic ends. It is also legitimate to point out that these quilt makers in effect "painted" with fabrics, joining colors and textures, their pallets the family scrapbags and those of their neighbors.

Considered as a creative entity, American pieced quilts are a large, distinct body of work with its own history, techniques and styles, one which exhibits some particularly American design traits: a traditional, reductive approach to visual problems, which tended towards simplification of imported forms and the production of unfussy native ones; vigorous, innovative forms; the bold use of color. Each quilt within the whole is answerable to aesthetic judgements. Many quilts are mediocre or merely pleasing visually, some are outstanding as decorative art, a few, to our eyes, stand as extraordinary visual works. While designs were often shared, no two quilts were ever alike; the women with superior eyes and sensibilities produced the most moving examples.

The vitality of the craft—its continuing ability to function as a means of personal expression—has assured its survival long after the practical need for its product has disappeared in most of the country. Especially in rural America quilt-making remains an honored skill. Women still invent new patterns, still follow many now hundreds of years old, an unbroken creative line threading over three centuries of American life.

<div style="text-align: right;">Jonathan Holstein</div>

Bibliography:

Beer, Alice Baldwin, *Trade Goods,* Washington, D.C., Smithsonian Institution Press, 1970.

Carlyle, Lilian Baker, *Pieced Work and Applique Quilts at Shelburne Museum*, Museum Pamphlet Series, Number 2, Shelburne, Vermont, The Shelburne Museum, n.d.

Christensen, Erwin O., *The Index of American Design*, New York, The Macmillan Col., 1950.

Colby, Averil, *Patchwork*, London, B.T. Batsford Ltd., 1958.

Colby, Averil, *Patchwork Quilts*, New York, Charles Scribner's Sons, 1965.

Colby, Averil, *Quilting*, New York Charles Scribner's Sons, 1971.

Dunham, Lydia Roberts, «Denver Art Museum Quilt Collection,» *The Denver Art Museum Quarterly*, Winter 1963.

Dunton, William Rush, *Old Quilts*, Catonsville, Maryland, 1946.

Finley, Ruth E., *Old Patchwork Quilts and the Women Who Made Them*, Philadelphia, J. B. Lippincott Co., 1929.

Haas, Louise Kraus, *Quilts, Counterpanes and Related Printed Fabrics*, Santa Monica, Coromandel, 1956.

Hake, Elizabeth, *English Quilting, Old and New*, London, B. T. Batsford, Ltd., 1937.

Hall, Carrie A. and Kretsinger, Rose G., *The Romance of the Patchwork Quilt in America*, Caldwell, Idaho, The Caxton Printers, Ltd., 1935; reprinted by Bonanza Books, New York.

Harbeson, Georgiana, *American Needlework*, New York, Coward-McCann, 1938.

Hinson, Dolores A., *Quilting Manual*, New York, Hearthside Press, Inc., 1966.

Holstein, Jonathan, *Abstract Design in American Quilts*, New York, The Whithney Museum of American Art, 1971.

Hunton, W. Gordon, *English Decorative Textiles*, London, John Tiranti & Co., 1930.

Ickis, Margaret, *The Standard Book of Quilt Making and Collecting*, N. P., Greystone Press, 1949; reprinted by Dover Publications, Inc., New York, 1959.

Lichten, Frances, *Folk Art of Rural Pennsylvania*, New York, Charles Scribner's Sons, 1946.

Little, Frances, *Early American Textiles*, New York, The Century Co., 1931.

Lord, Priscilla and Foley, Danial, *The Folk Arts and Crafts of New England*, New York, Chilton Books, 1956.

McKim, Ruby Short, *One hundred and One Patchwork Patterns*, n. p., McKim Studios, 1931; reprinted by Dover Publications, Inc., New York, 1962.

Percival, MacIver, *The Chintz Book*, New York, Frederick Stokes, 1923.

Peto, Florence, *Historic Quilts*, New York, The American Historical Company, Inc., 1939.

Peto, Florence, *American Quilts and Coverlets*, New York, Chanticleer Press, 1949.

Robacker, Earl F., *Touch of the Dutchland*, New York, A.S. Barnes & Co., Inc., 1956.

Robertson, Elizabeth Wells, *American Quilts*, New York, The Studio Publications, Inc., 1948.

Small, Cassie Paine, *How to Know Textiles*, Boston, Ginn & Co., 1932.

Walton, Perry, *The Story of Textiles*, Boston, Walton Advertising and Printing Co., 1925.

Webster, Marie D., *Quilts: Their Story and How to Make Them*, New York, Doubleday, Doran & Co., Inc., 1928.

White, Margaret, *Quilts and Counterpanes in the Newark Museum*, Newark, New Jersey, The Newark Museum, 1948.

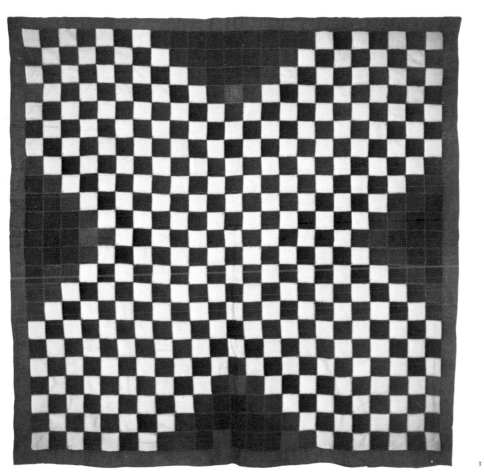

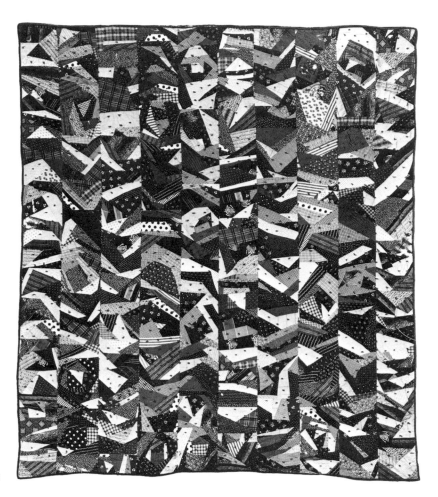

2

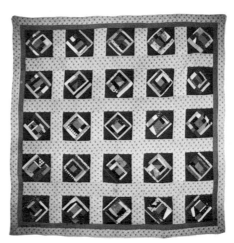

3

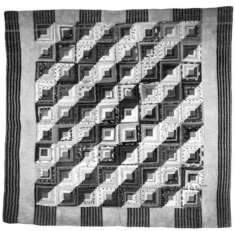

4

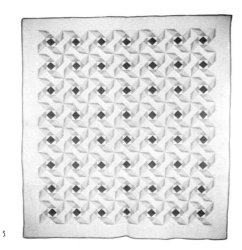

5

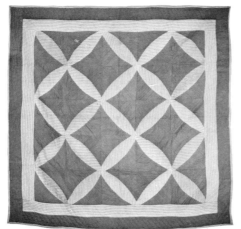

6

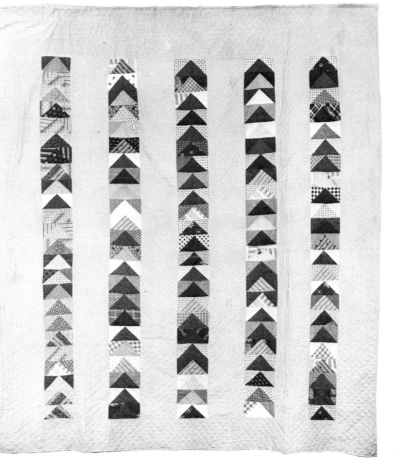

7

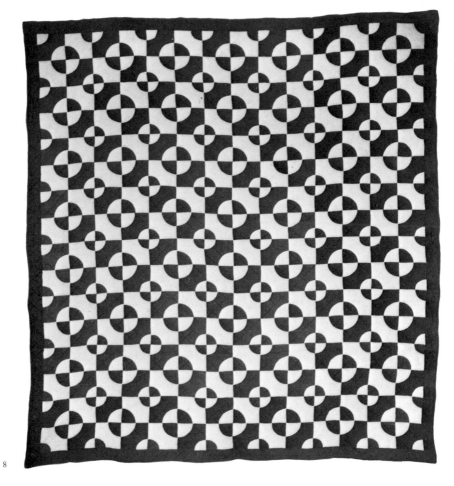

8

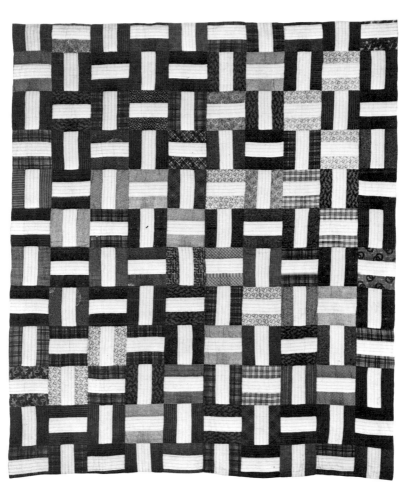

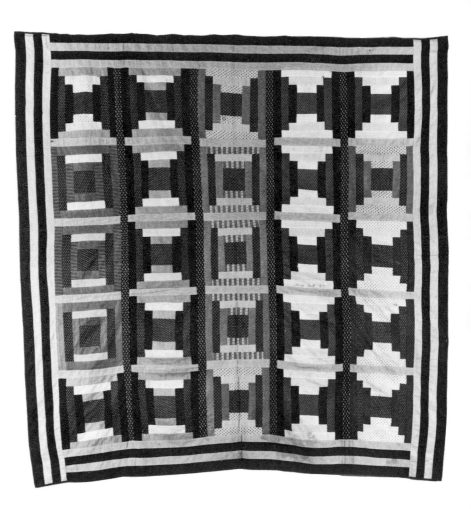

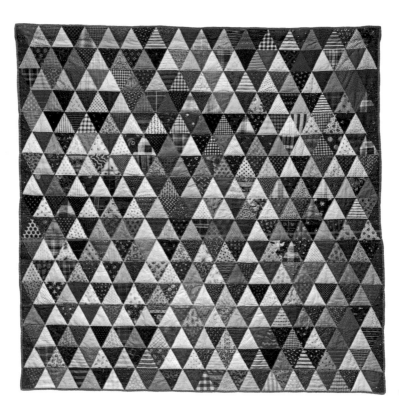

11

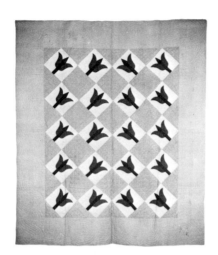

12

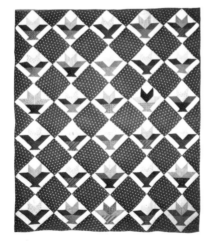

13

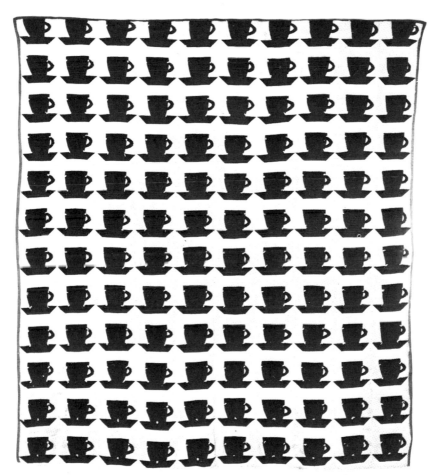

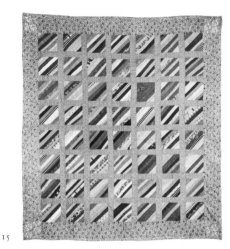

15

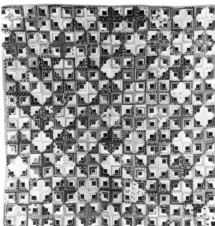

16

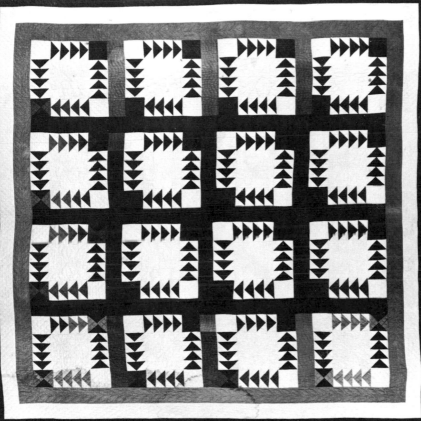

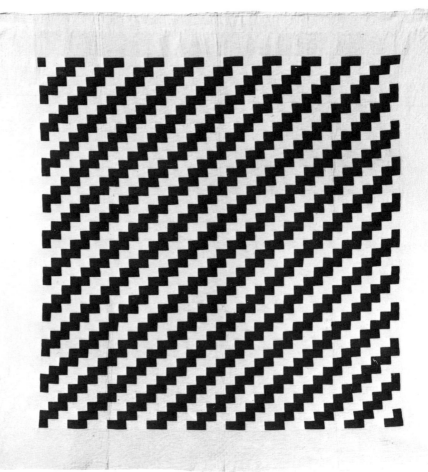

18

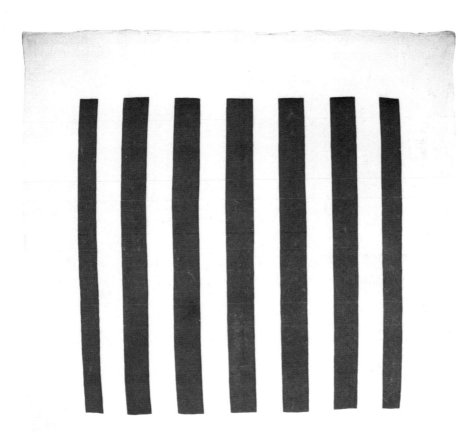

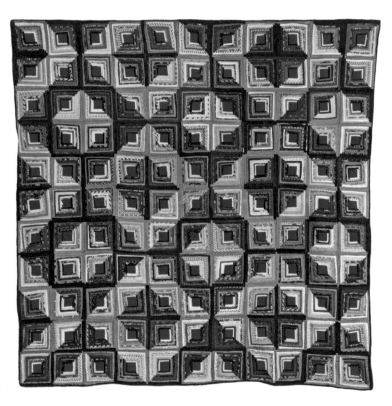

20

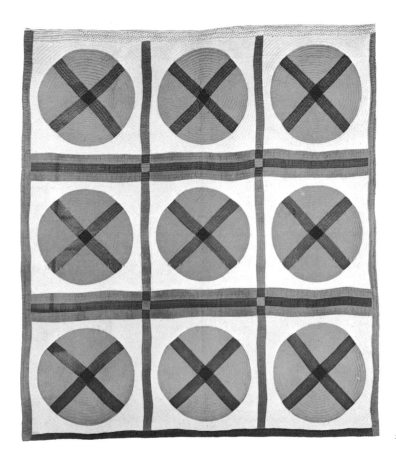

21

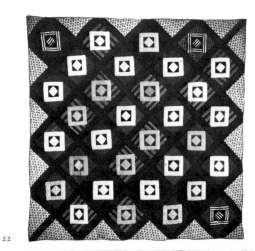

22

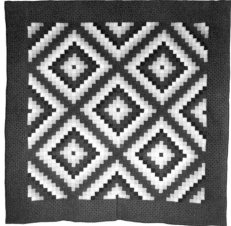

23

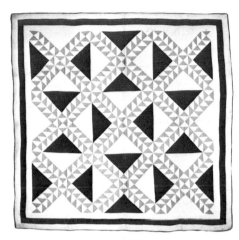

24

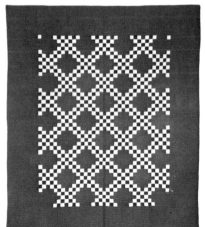

25

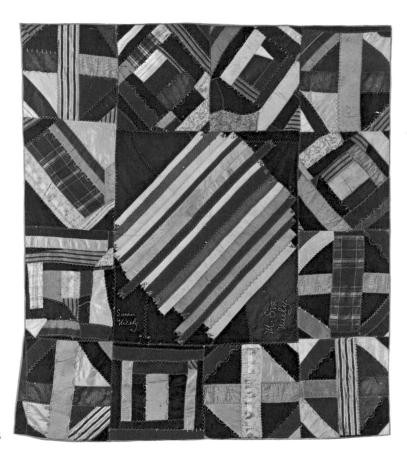

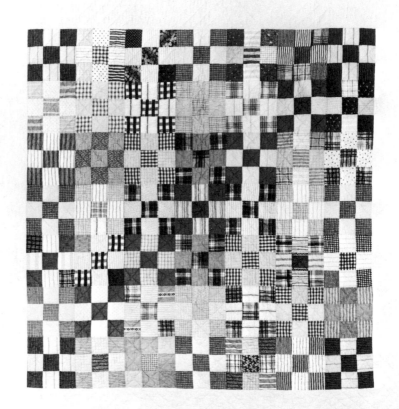

28

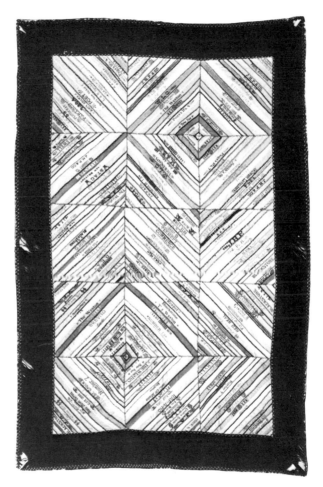

29

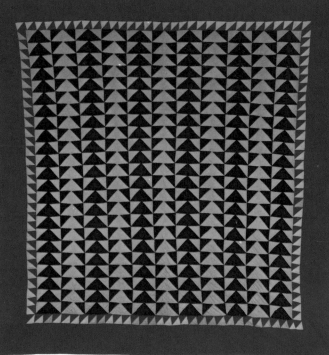

30

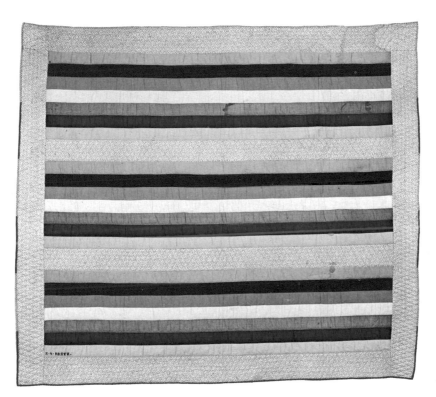

31

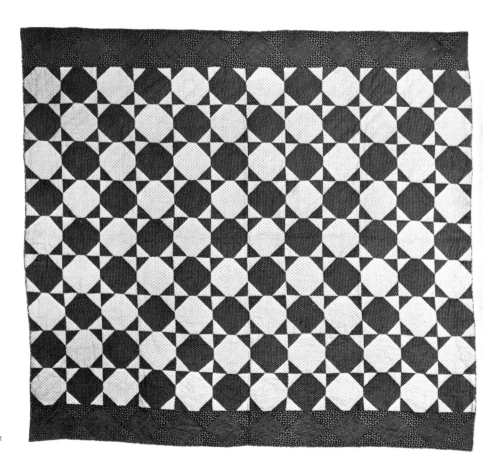

32

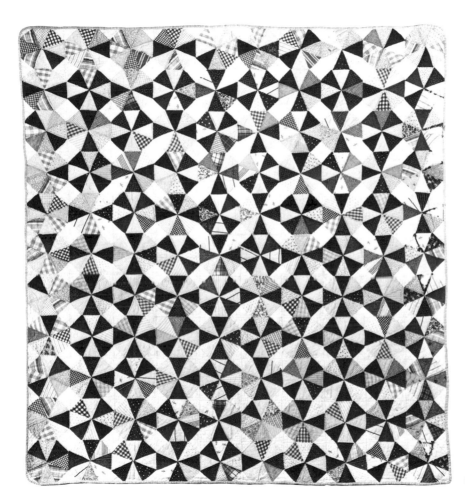

33

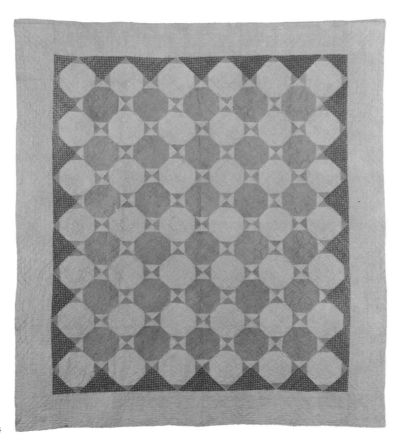

34

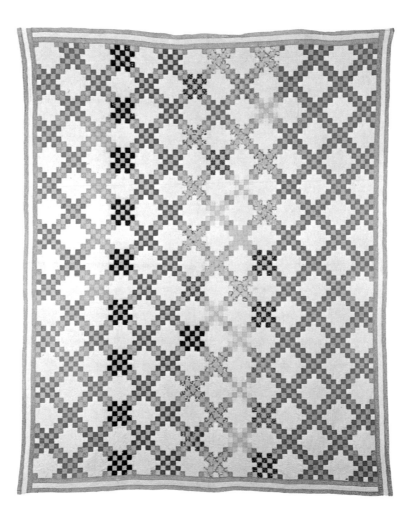

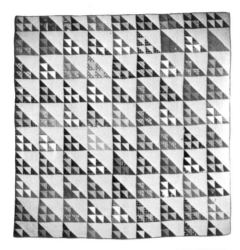

36

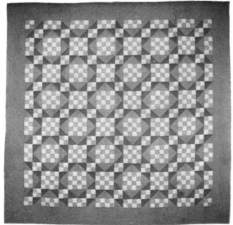

37

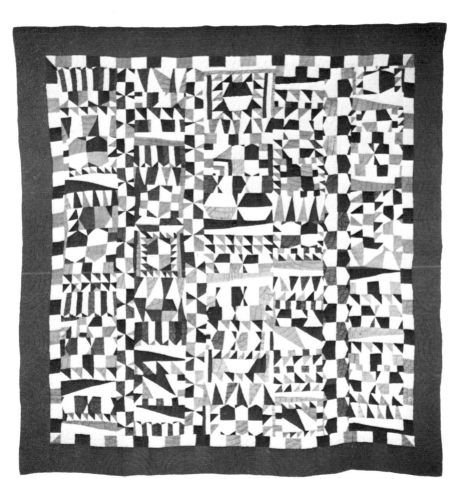

38

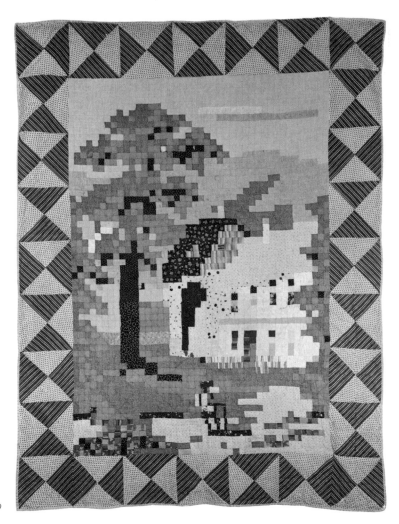

39

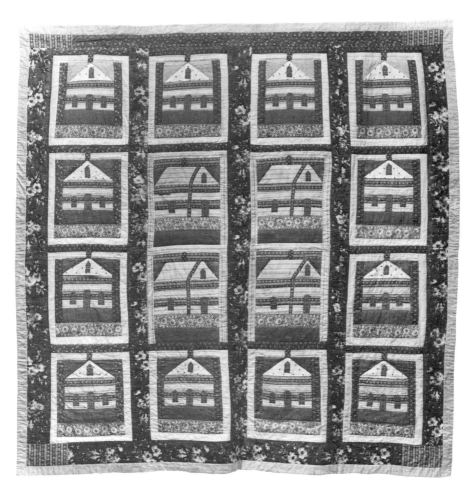

40

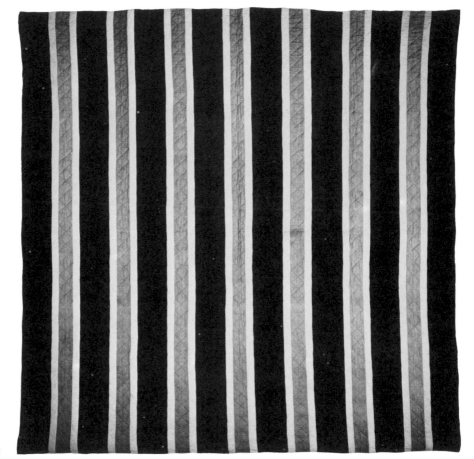

41

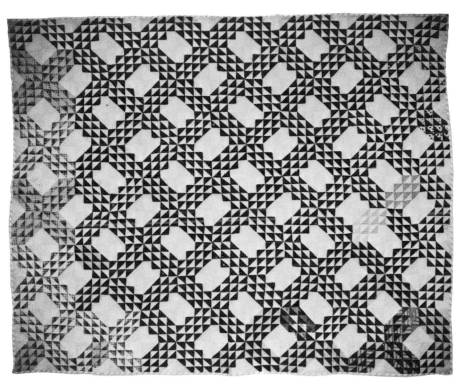

42

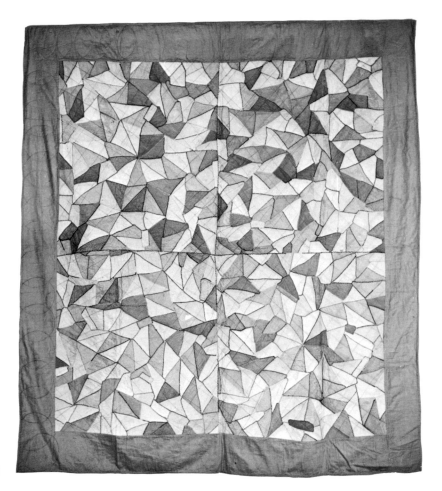

43

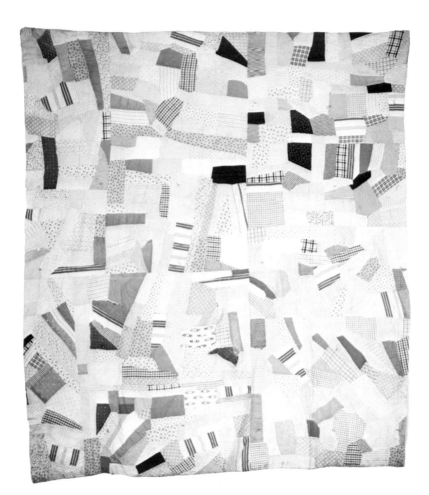

44

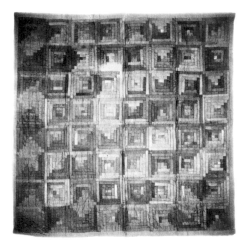

45

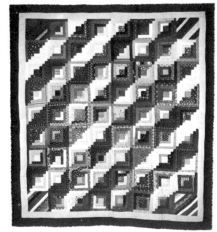

46

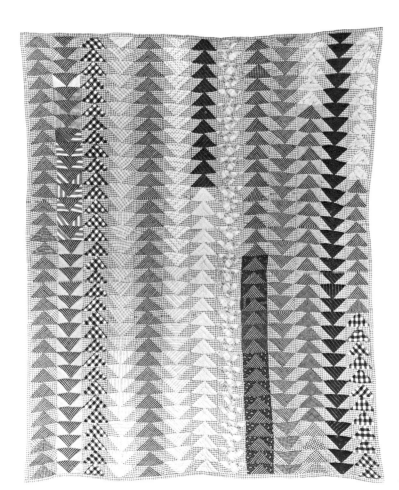

47

48

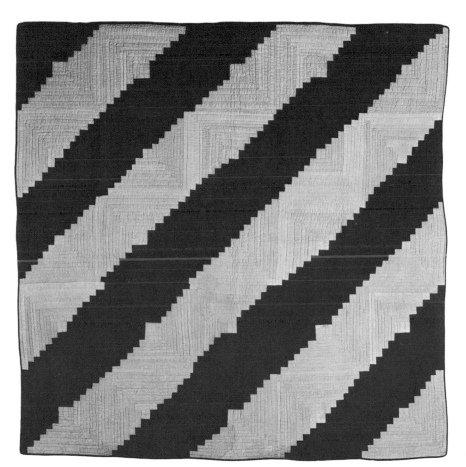

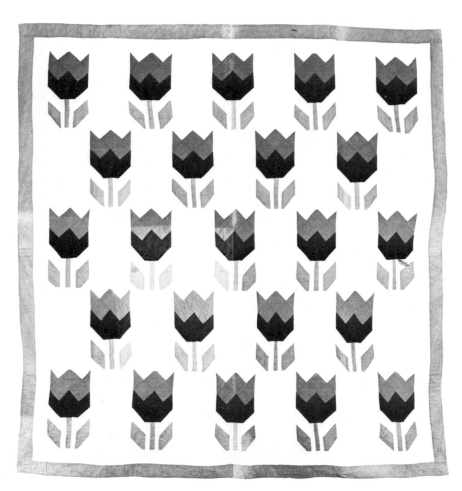

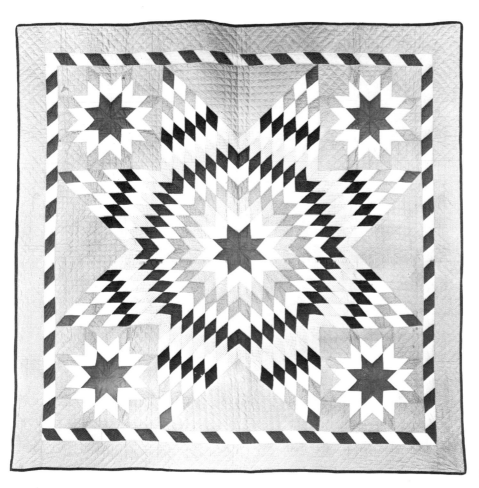

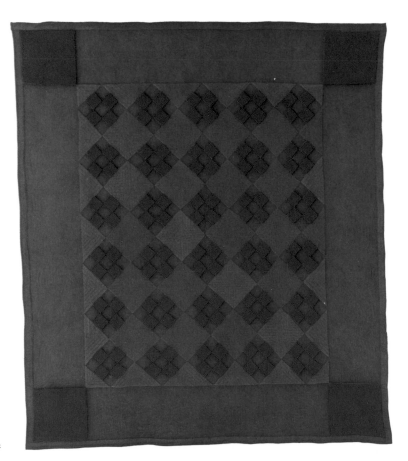

52

53

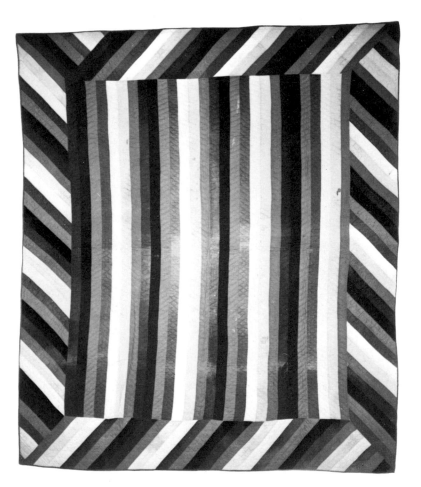

54

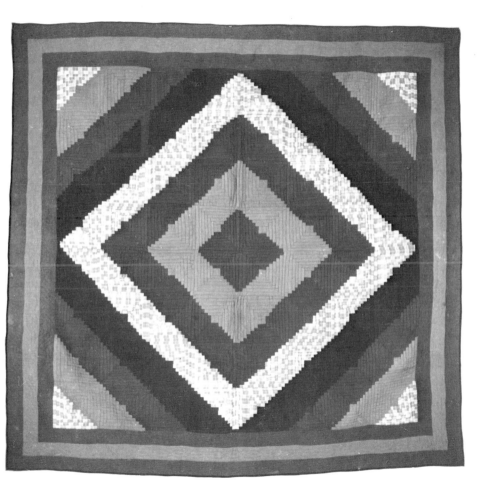

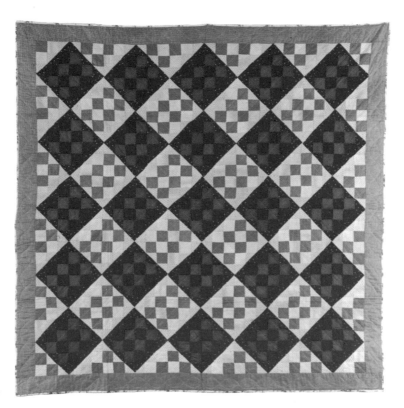

56

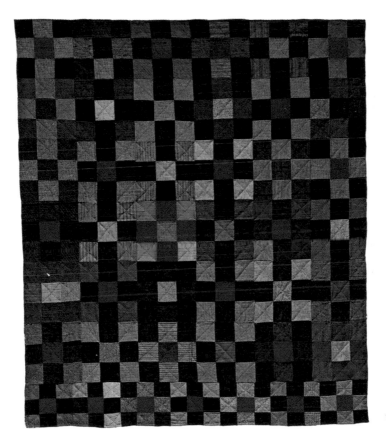

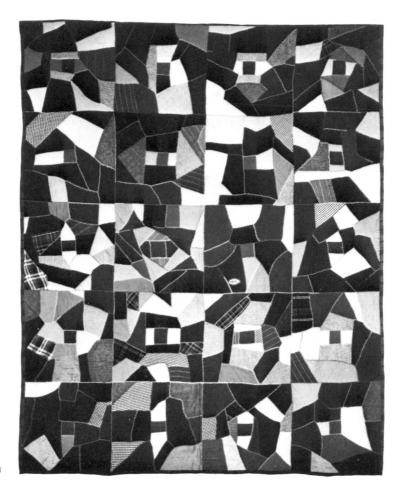

58

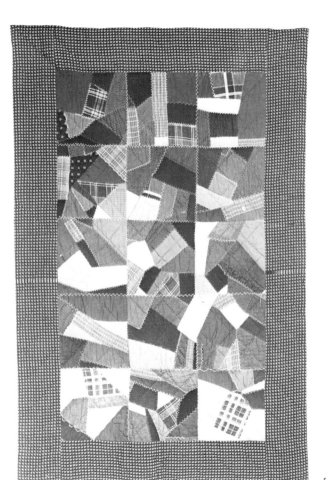

59

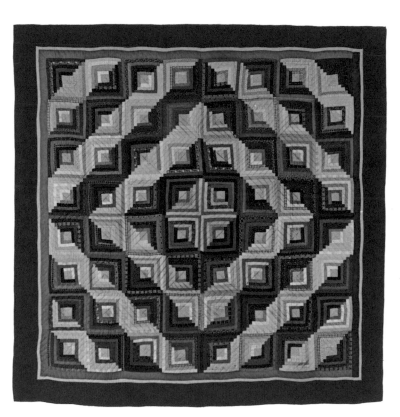

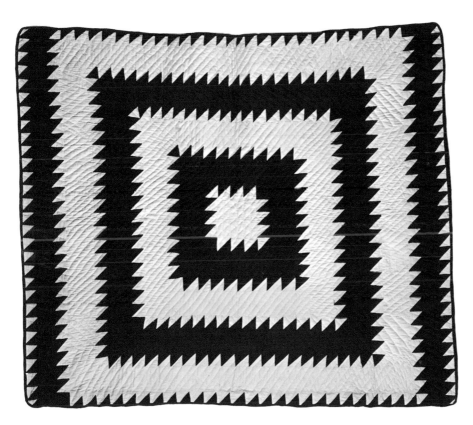

61

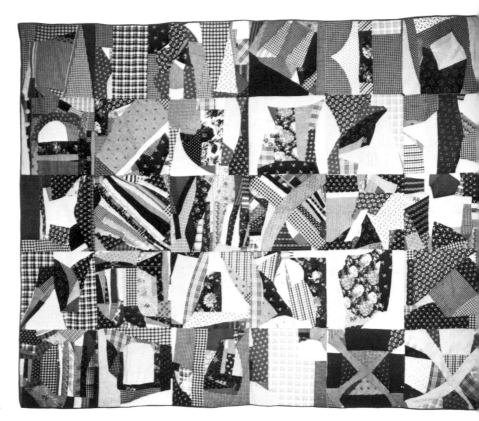

62

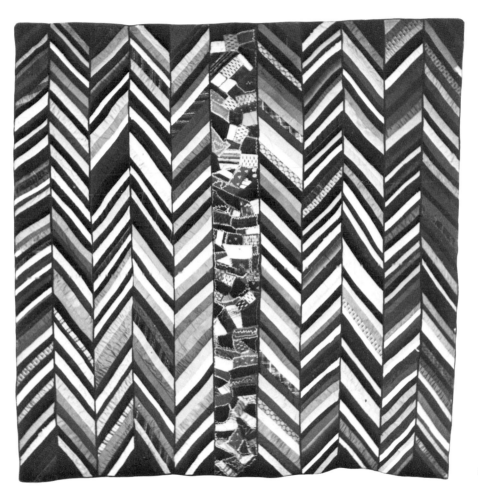

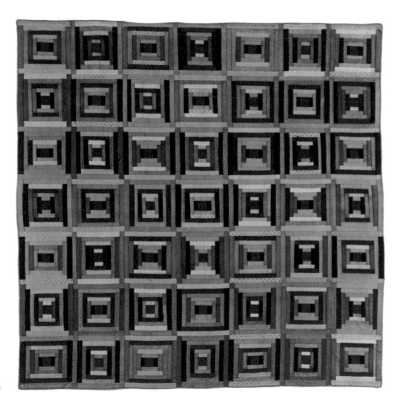

64

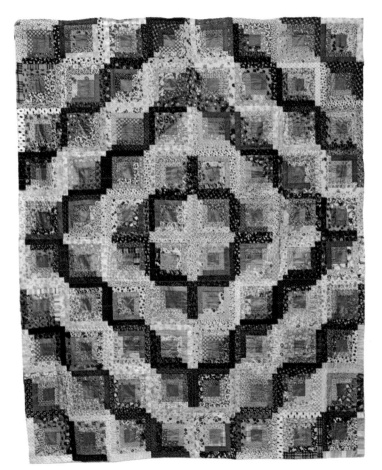

65

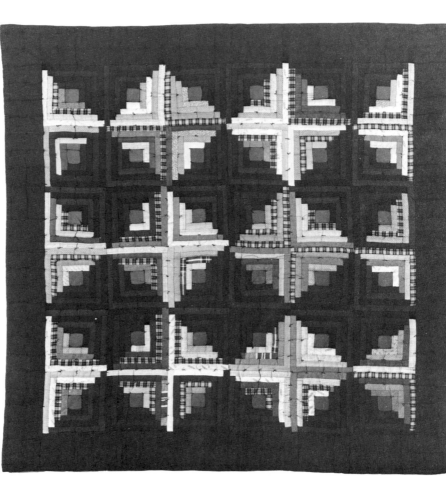

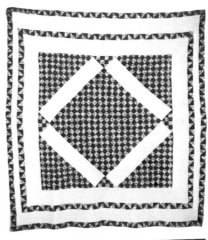

67

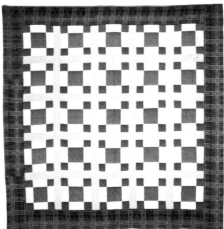

68

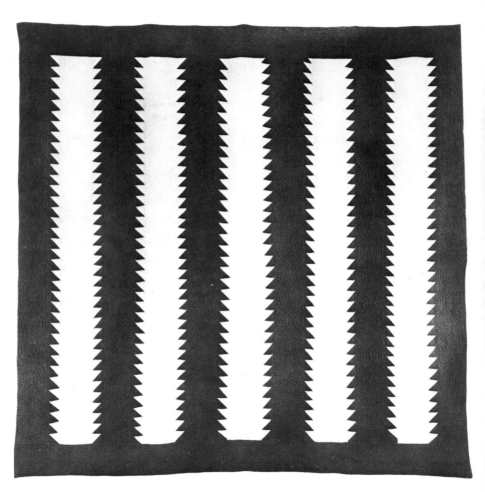

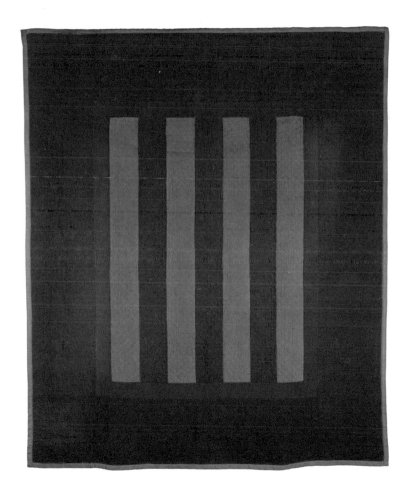

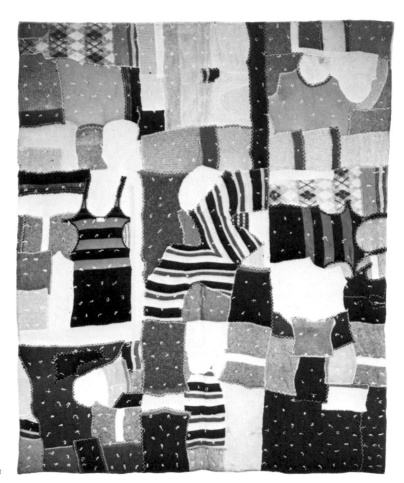

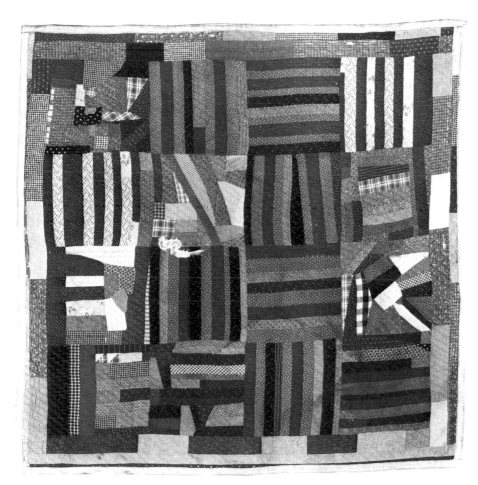

72

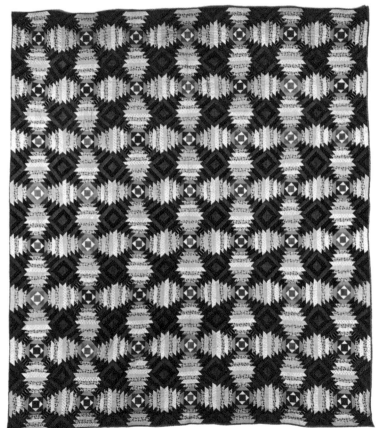

73

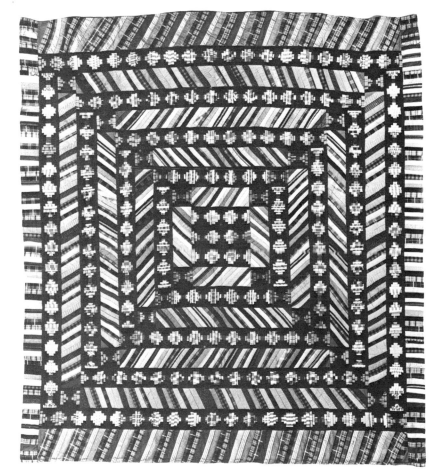

74

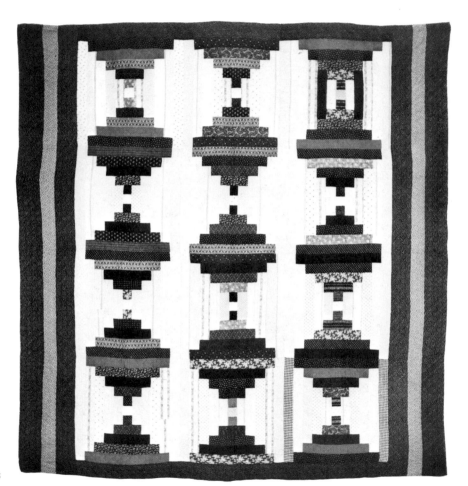

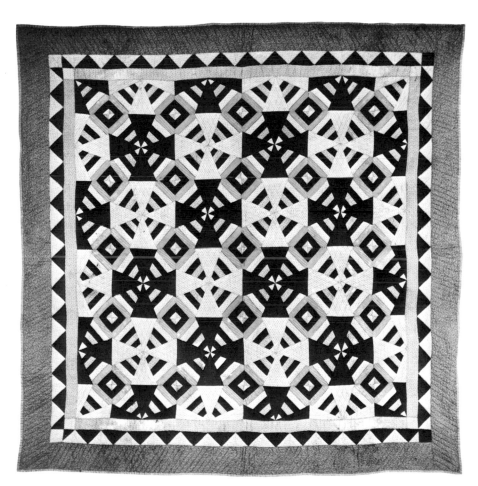

76

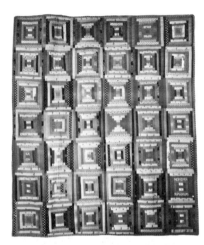

77

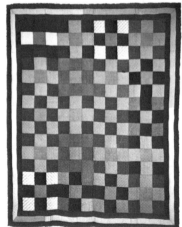

78

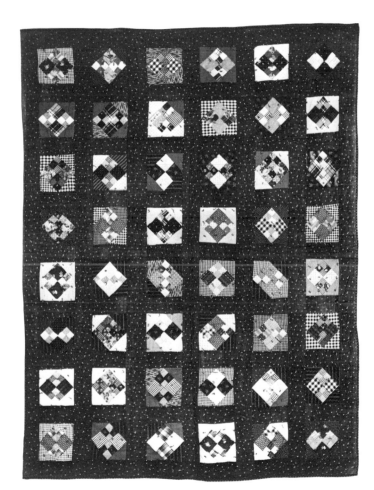

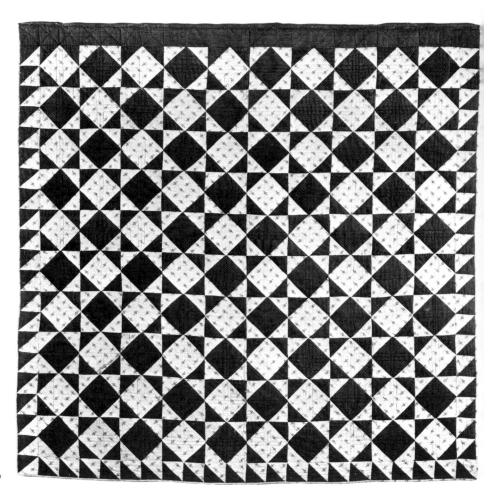

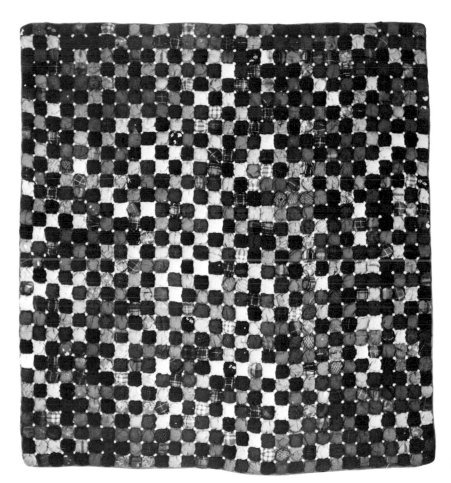

81

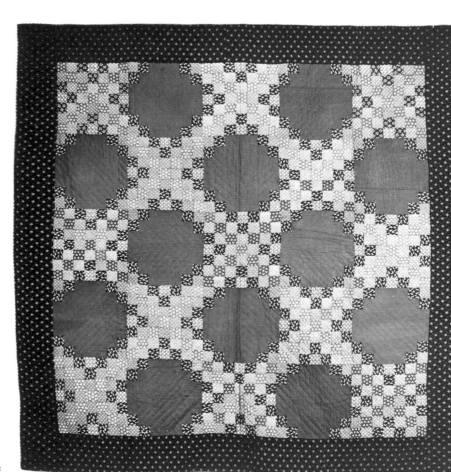

82

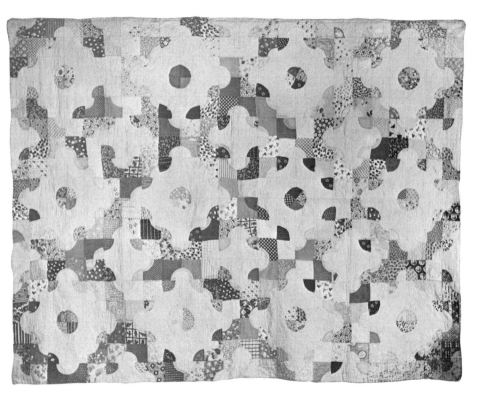

83

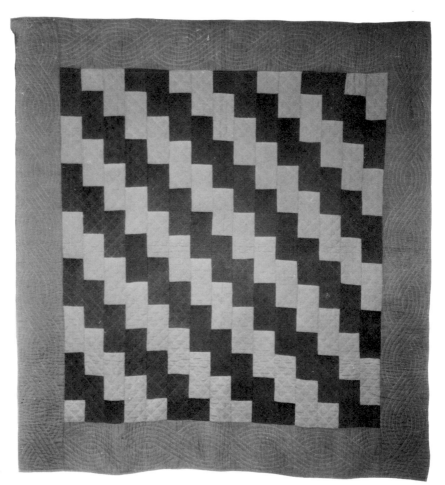

84

List of plates:

19. Bars. Pennsylvania. Ca. 1890. Cotton. 80×77 in, 203×195 cm.
20. "Log Cabin" blocks arranged in a pattern called "Light and Dark". Pennsylvania. Ca. 1860. Wool. 77×75½ in, 195×192 cm.
21. Circles with crosses. Colorado. Ca. 1900. Cotton. 84½×75½ in, 214×190 cm.
22. "King's Crown" blocks. Pennsylvania. Ca. 1860. Cotton. 79×79 in, 201×201 cm.
23. "Grandma's Dream." Pennsylvania. Ca. 1885. Cotton. 75×75 in, 190×190 cm.
24. "Old Maid's Ramble." New England. Ca. 1890. Cotton. 73½×73½ in, 186×186 cm.
25. "Double Irish Chain." Maine. Ca. 1890. Cotton. 86×74 in, 193×188 cm.
26. "Crazy." Indiana. Ca. 1890. Silk and velvet. 72×70 in, 183×178 cm.
27. "Baby Blocks." Pennsylvania. Ca. 1880. Cotton. 83½×81 in, 214×208 cm.
28. "Nine Patch Block." Pennsylvania. Ca. 1900. Cotton. 68×68 in, 172×172 cm.
29. Stripes. Maine. Ca. 1890. S. 63½×41½ in, 159×106 cm.
30. "Wild Goose Chase." Pennsylvania. Ca. 1910. Cotton. 88×86 in, 223×207 cm.
31. "Rainbow." Pennsylvania. Ca. 1880. Cotton. 73×80 in, 185×208 cm.
32. "Robbing Peter to pay Paul." Pennsylvania. Ca. 1880. Cotton. 77×84 in, 195×214 cm.
33. "Kaleidoscope." Pennsylvania. Ca. 1869. Cotton. 70½×66½ in, 179×169 cm.
34. "Robbing Peter to pay Paul." Pennsylvania. Ca. 1870. Cotton. 85×81 in, 216×204 cm.
35. "Double Irish Chain." Pennsylvania. Ca. 1850. Cotton. 93½×78 in, 237×198 cm.
36. "Birds in the Air." Pennsylvania. Ca. 1860. Cotton. 83×80 in, 211×203 cm.
37. "Road to California." Pennsylvania. Ca. 1900. Cotton. 78×78 in, 198×198 cm.
38. "Crazy." New England. Ca. 1920. Cotton. 88×84 in, 224×213 cm.
39. House in the country. New England. Ca. 1870. Cotton. 75×57½ in, 190×146 cm.
40. "Schoolhouse." New Hampshire. Ca. 1880. Cotton. 77×76 in, 195×193 cm.
41. Stripes. Pennsylvania. Ca. 1880. Cotton. 84×84 in, 213×213 cm.

42. "Ocean Waves." Sandgate, Vermont. Ca. 1870. Cotton. 78×96½ in, 198×240 cm.

43. "Crazy." Pennsylvania. Ca. 1940. Cotton. r. 85×79 in, 214×201 cm.

44. "Crazy." Vermont. Ca. 1920. Cotton. 75½×64 in, 191×162 cm.

45. "Log Cabin" blocks arranged in a pattern called "Straight Furrow". Pennsylvania. Ca. 1870. Wool. 75×72 in, 190×182 cm. (An Amish quilt.)

46. "Log Cabin" blocks arranged in a pattern called "Straight Furrow". New Jersey. Ca. 1875. Cotton. 77½×69 in, 171×175 cm.

47. "Wild Goose Chase." Pennsylvania. Ca. 1850. Cotton. 67×55½ in, 170×141 cm.

48. "Flower Baskets." New Jersey. Ca. 1880. Cotton. 69×67 in, 175×170 cm.

49. "Log Cabin" blocks arranged in a pattern called "Straight Furrow". Pennsylvania. Ca. 1860. Cotton. 74×74 in, 188×188 cm.

50. "Modernistic Tulips." Pennsylvania. Ca. 1910. Cotton. 82×76 in, 208×193 cm.

51. "Star of Bethlehem." Pennsylvania. Ca. 1880. Cotton. 85½×82 in, 217×208 cm.

52. "Nine Patch Block." Pennsylvania. Ca. 1900. Wool. 83×72 in, 211×183 cm. (An Amish quilt.)

53. "Baby blocks." Pennsylvania. Ca. 1875. Cotton. 78×73 in, 198×185 cm.

54. "Rainbow." Pennsylvania. Ca. 1890. Cotton. 84×71 in, 213×180 cm.

55. "Log Cabin" blocks arranged in a pattern called "Barn Raising". Pennsylvania. Ca. 1870. Wool and cotton. 78×77 in, 198×195 cm. (An Amish quilt.)

56. Square patches in cross form. New Jersey. Ca. 1860. Cotton. 87½×87½ in, 222×222 cm.

57. Squares. New Jersey. Ca. 1890. Wool. 64×74 in, 162×193 cm.

58. "Crazy." Pennsylvania. Ca. 1875. Wool. 88×70 in. 224×178 cm.

59. "Crazy." Pennsylvania. Ca. 1875. Cotton and wool. 78½×53½ in, 199×135 cm.

60. "Log Cabin" blocks arranged in a pattern called "Barn Raising". Pennsylvania. Ca. 1880. Cotton. 84×82½ in, 213×210 cm.

61. "Sawtooth." Massachusetts. Ca. 1875. Cotton. 77½×88½ in, 196×224 cm.

62. "Crazy." Massachusetts. Ca. 1860. Cotton. 84×100½ in, 213×255 cm.

63. Stripes with "crazy" center panel. Pennsylvania. Ca. 1875. Silk and velvet. 78×75 in, 198×190 cm.

64. "Log Cabin" blocks arranged in a pattern called "Courthouse Steps". Pennsylvania. Ca. 1850. Wool. 86½×85 in, 220×216 cm.
65. "Log Cabin" blocks arranged in a pattern called "Barn Raising". New Jersey. Ca. 1920. Cotton. 88×70 in, 224×178 cm. (A quilt top.)
66. "Log Cabin" blocks arranged in a pattern called "Light and Dark". Pennsylvania. Ca. 1875. Wool. 70×67 in, 178×170 cm.
67. Squares. Pennsylvania. Ca. 1935. Cotton. 84×78½ in, 213×200 cm.
68. "Nine Patch Block." Pennsylvania. Ca. 1860. Cotton. 84×84 in, 213×213 cm.
69. "Tree Everlasting." Pennsylvania. Ca. 1850. Cotton. 72×73 in, 183×185 cm.
70. Bars. Pennsylvania. Ca. 1860. Wool. 83½×69½ in, 212×178 cm. (An Amish quilt.)
71. "Crazy." New England. Ca. 1940. Wool. 88×72 in, 224×183 cm.
72. "Crazy." Pennsylvania. Ca. 1850. Cotton. 73×73 in, 186×186 cm.
73. "Pineapples." New Jersey. Ca. 1850. Cotton. 92×81 in, 235×207 cm.
74. "Log Cabin" blocks arranged in a pattern called "Courthouse Steps". Pennsylvania. Ca. 1875. Wool and silk. 89½×83½ in, 226×212 cm.
75. "Log Cabin" blocks arranged in a pattern called "Courthouse Steps". Pennsylvania. Ca. 1870. Cotton. 76×70 in, 189×178 cm.
76. "Spider Web." Pennsylvania. Ca. 1890. Cotton. 81½×81½ in, 208×208 cm.
77. "Log Cabin" blocks arranged in a pattern called "Courthouse Steps". Pennsylvania. Ca. 1850. Cotton, silk, wool. 84×73 in, 213×185 cm.
78. "Nine Patch Block." Pennsylvania. Ca. 1875. Wool. 82×72 in, 215×173 cm.
79. "Four Patch Block." Pennsylvania. Ca. 1860. Cotton. 86×65 in, 214×167 cm.
80. "Shoo Fly." Vermont. Ca. 1860. Cotton. 77×77 in, 193×193 cm.
81. Puffs. Maine. Ca. 1875. Wool and cotton. 76×70 in, 193×178 cm.
82. "Triple Irish Chain." Pennsylvania. Ca. 1875. Cotton and wool. 78×75 in, 197×190 cm.
83. "Around the World." New Hampshire. Ca. 1920. Cotton. 79×101½ in, 201×257 cm.
84. "Streak o' Lightning." Pennsylvania. Ca. 1880. Wool. 73×71 in, 185×180 cm. (An Amish quilt.)